MONA-OPOLY

HOW MONA LISA AFFECTED OTHERS

JUDY F. HILBISH

Copyright © 2013 by Judy F. Hilbish
All Rights Reserved
ISBN:9781492245452

Mona-Opoly

Mona Lisa has left an impression on all who have seen her. Many ponder her mysteries. Who was she? Was Mona Lisa a she or was Leonardo da Vinci playing a trick by painting himself with his frown turned upside down? Those who have gazed at her come away trying out her smile, her sleepy squint, or her coy hand gesture. If we all have a little bit of Mona Lisa in us, then how does she affect you? How has she affected other famous people you know or have read about, like . . .

LAWRENCE OF ARABIA MEETS MONA LISA

More Mona Lisa's have been brought to light lately. But there was an even earlier Mona. She has survived, indirectly, through the efforts of T. E. Lawrence and Gertrude Bell.

Before WWI Lawrence was a Middle East archaeologist. During his tour in the British Army, he met and subsequently worked with another archaeologist, Gertrude Bell. After the war, Lawrence returned to England where he promoted awareness of the Middle East. Bell remained in Iraq working hard to keep antiquities in their home country. She laid the groundwork in 1928 for the National Museum of Iraq in Bagdad, the home of the Mona Lisa of Nimrud.

The ivory head, carved in 600 BC, was discovered in the 1900s. In 2003, the museum staff, under extreme pressure of invasion and the prospect of subsequent looting, hid this treasure along with many others.

It is through the groundwork of T. E. Lawrence and Bell that this earliest Mona Lisa survived. Mona Lisa is obviously pleased with Lawrence's role in saving her ancient predecessor.

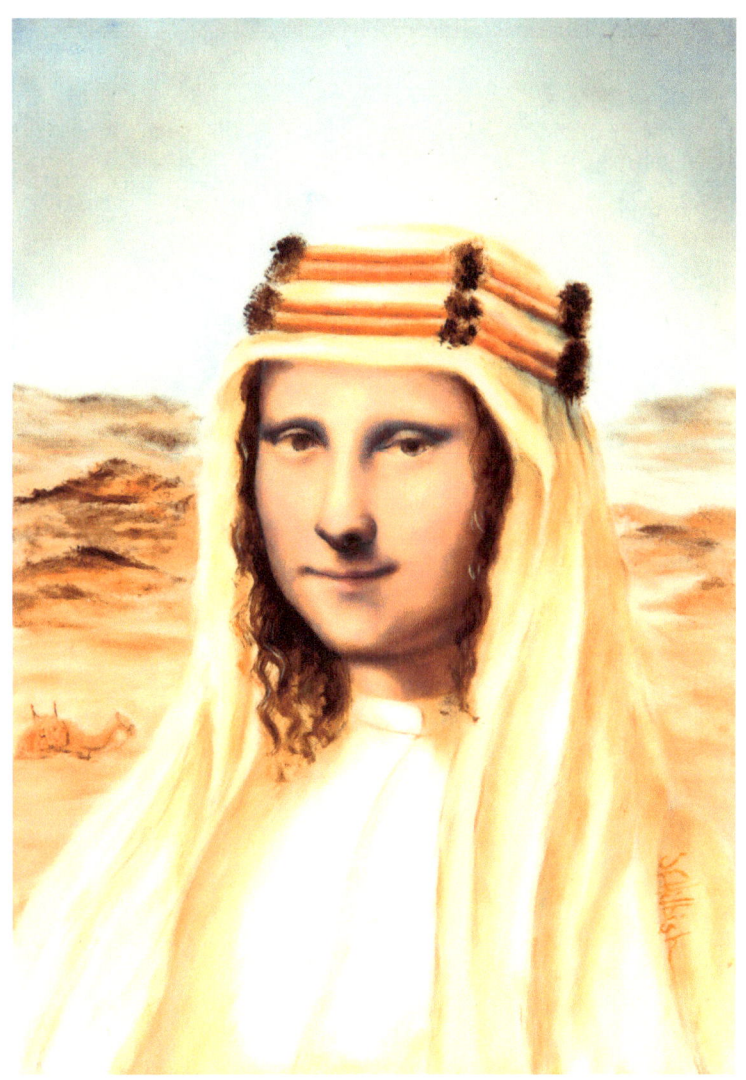

LAWRENCE OF ARABIA
MEETS MONA LISA

GEORGE WASHINGTON MEETS MONA LISA

Mysteries abound surrounding Leonardo da Vinci's Mona Lisa. Some feel it is full of hidden Masonic symbols. The Free Masons included such notables as George Washington and Ben Franklin, who created the seal of the United States, but not Leonardo. But a close relative of Leonardo's was prominent in the Masons. It is only Dan Brown who believes that Leonardo was a Free Mason, but the times that Leonardo lived in were full of spies and intrigue, thus his use codes and ciphers, just not Masonic ones.

Michael Domoretsky in 2008 announced in the Gloucester Times that Leonardo embedded codes in Mona Lisa's face. Likewise many find hidden meaning in the seal of the United States which lies in its Masonic symbols. Both Leonardo and Franklin lived in eras of secret societies and the use of codes. Did Ben Franklin, who had lived in Paris, also see codes in the Mona Lisa and incorporate these symbols into the great seal? And why does George Washington on the dollar bill that Franklin had a hand in designing have Mona Lisa's smile? Does he know something we do not? Every time a dollar bill is used, these mysteries pass to another person.

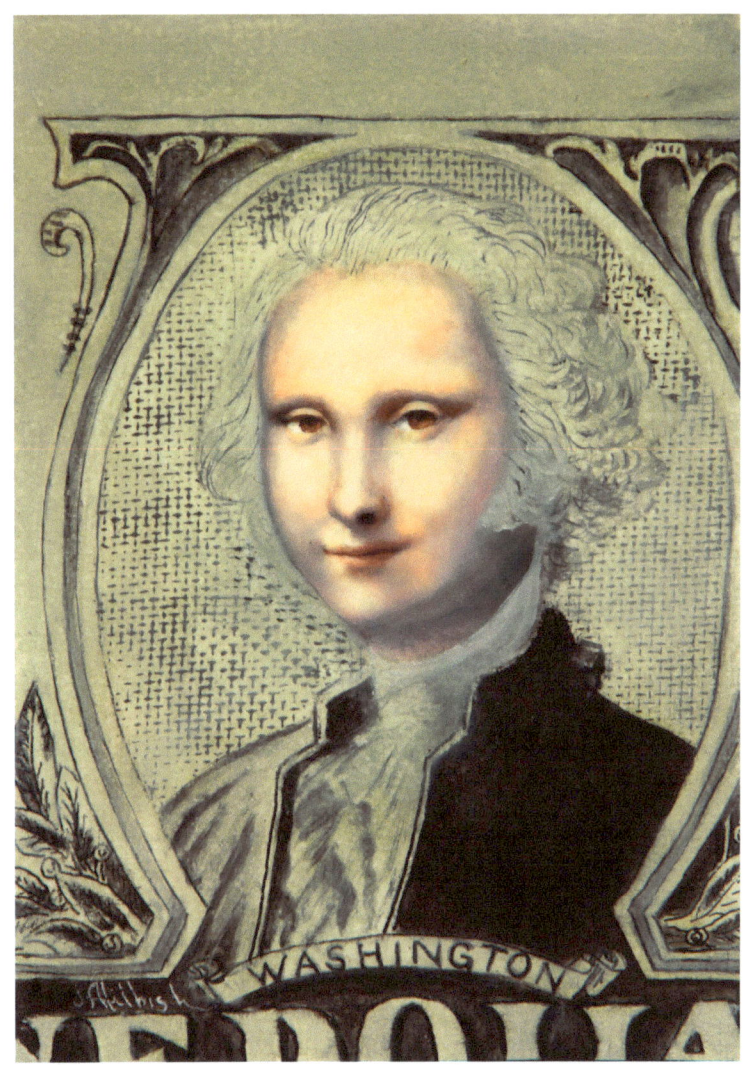

GEORGE WASHINGTON
MEETS MONA LISA

ANNIE OAKLEY
MEETS MONA LISA

Annie Oakley, the Little Sure Shot of the Wild West, traveled to Europe as part of the Buffalo Bill's Wild West Show. She displayed her skills before the Queen of England and the king of Italy. Even shot the ashes off a cigarette held by the new Kaiser of Germany.

It was around 1888 on a visit to France to perform before the president, Marie Francois Sadi Carnot, that she probably first set her sights on the Mona Lisa. And the rest is history.

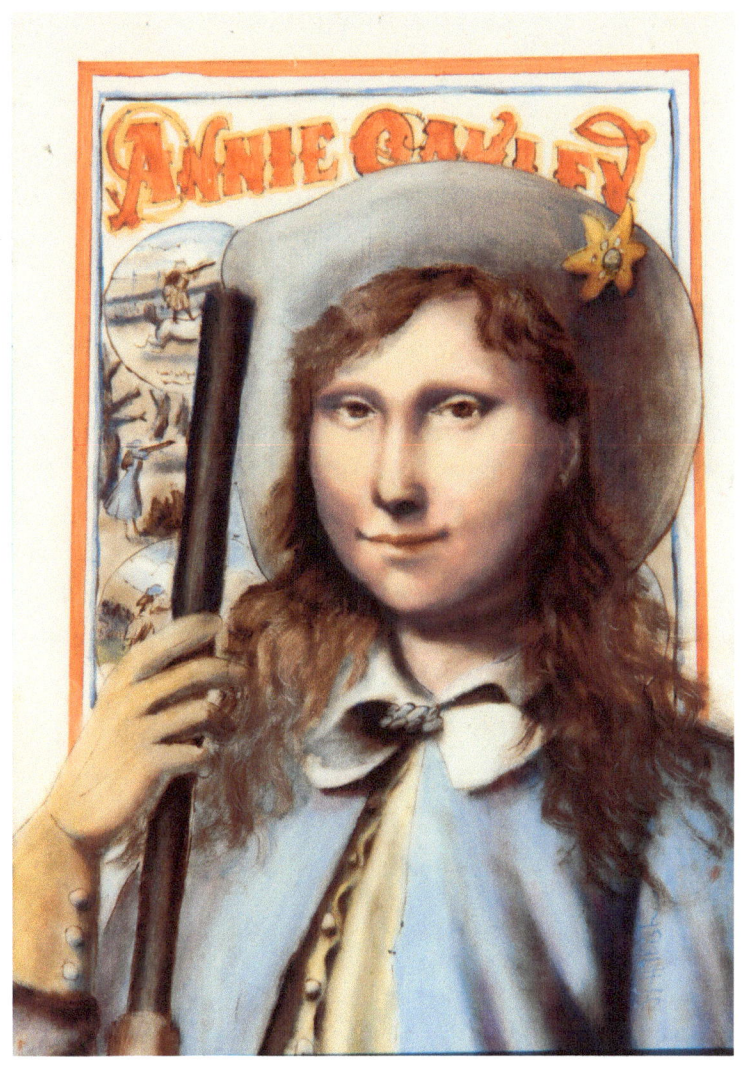

ANNIE OAKLEY
MEETS MONA LISA

MINNIE MOUSE MEETS MONA LISA

When Disney World opened in France, Minnie was thrilled and worked very hard to land a visit to the new playground. Minnie had a distant cousin who worked in the café at the Musée du Louvre.

When she contacted him during her visit to Paris, he remembered Minnie's passion for the Mona Lisa. After the business closed one night, Henri Mouse brought Minnie to the café for a late night snack. Afterwards he took her on a tour of the Musée du Louvre. On seeing the Mona Lisa, Ms. Mouse knew she was right in choosing Mona Lisa as her guiding star. She knew she had found her Soul Sister.

Mona-Opoly

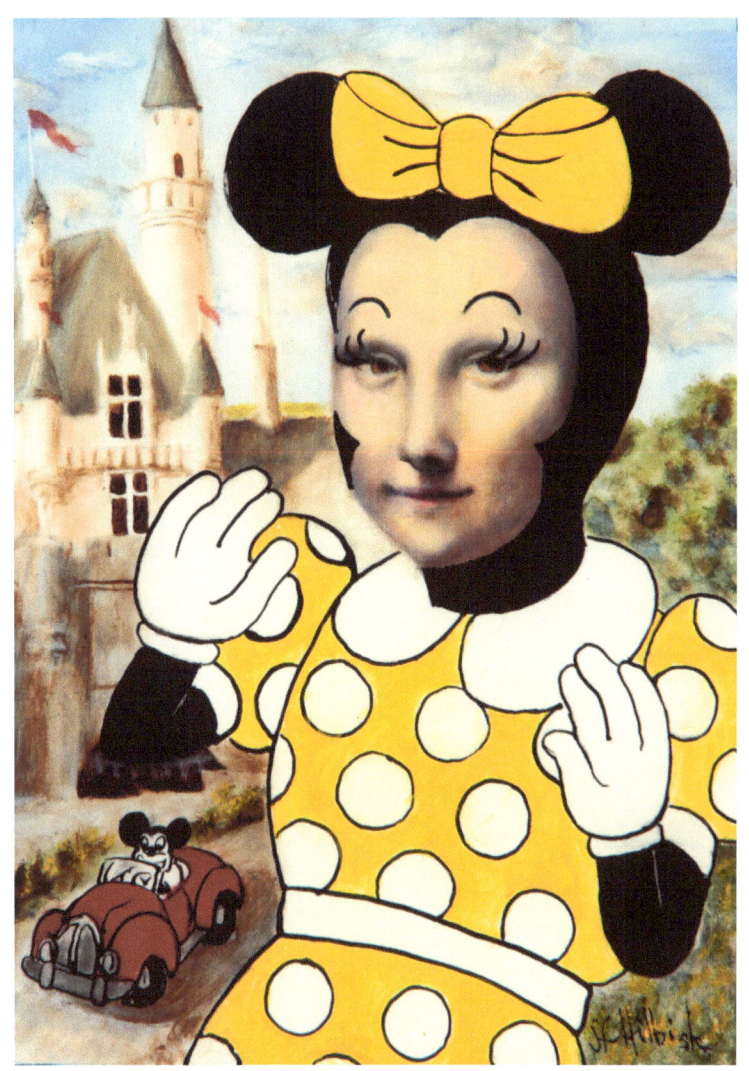

**MINNIE MOUSE
MEETS MONA LISA**

NAPOLEON BONAPARTE MEETS MONA LISA

It is not widely known that Napoleon Bonaparte slept under the triumphant watch of Mona Lisa, where she probably crept into his soul. She was a guest in his bedroom at Tuileries Palace in Paris before being moved to the Musee du Louvre in 1804.

In the noble pose of Bonaparte upon his Arabian Marengo in the painting "Napoleon Crossing the Alps" we get a glimpse of Mona Lisa's spirit bursting through as she nears her homeland of Italy.

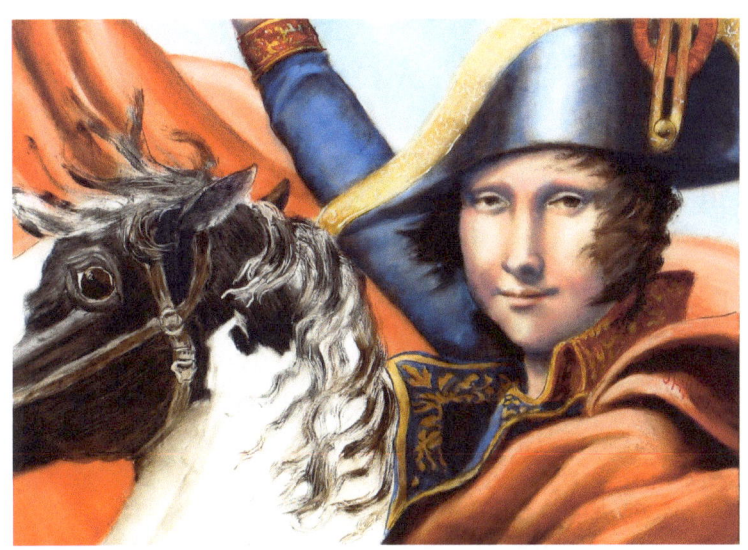

NAPOLEON BONAPARTE MEETS MONA LISA

DARTH VADER MEETS MONA LISA

Anakin Skywalker left his loving mother's side to pursue the life of a Jedi. But temptation of power was too great and Anakin turned to the Dark Side and became Darth Vader. In the end, when he is mortally wounded by the emperor while protecting his own son, Darth Vader asked that his life-giving helmet be removed so he could gaze upon the face of his son "with my own eyes".

As the loving child Anakin resurfaces and love shines in his eyes as he looks upon his son, we see that mysterious smile of Mona Lisa who intrigued all of mankind, even in "galaxies far, far away".

No doubt Mona Lisa's smile stems from the love she gave to her children. Mona Lisa was very fortunate to be able to gaze upon her children. Many women in her time did not survive to see their children grow up since mother or child often died in child-birth as did the mother of Luke, the wife of Anakin.

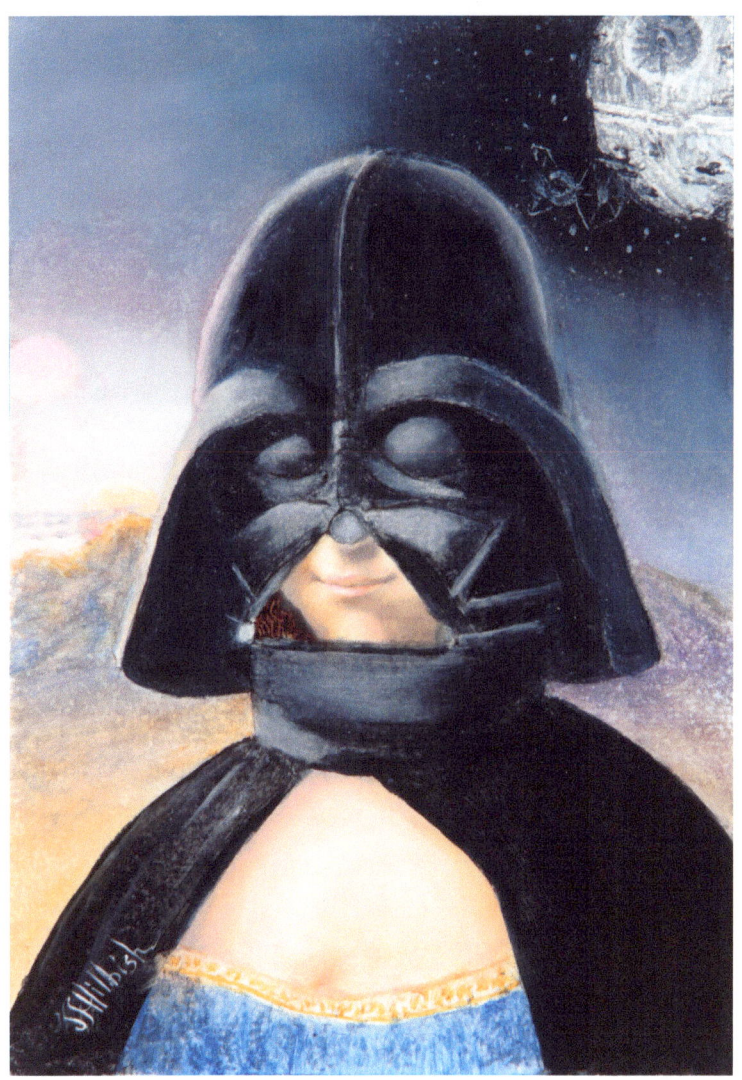

DARTH VADER MEETS MONA LISA

ALBERT EINSTEIN MEETS MONA LISA

Albert is known best for his break-through in physics. He won in science but he lost in love. No wonder since his famous formula actually reflected his secret true love: $E=mc^2$ is really E (enigma)=M (mona) x C (controversy) squared.

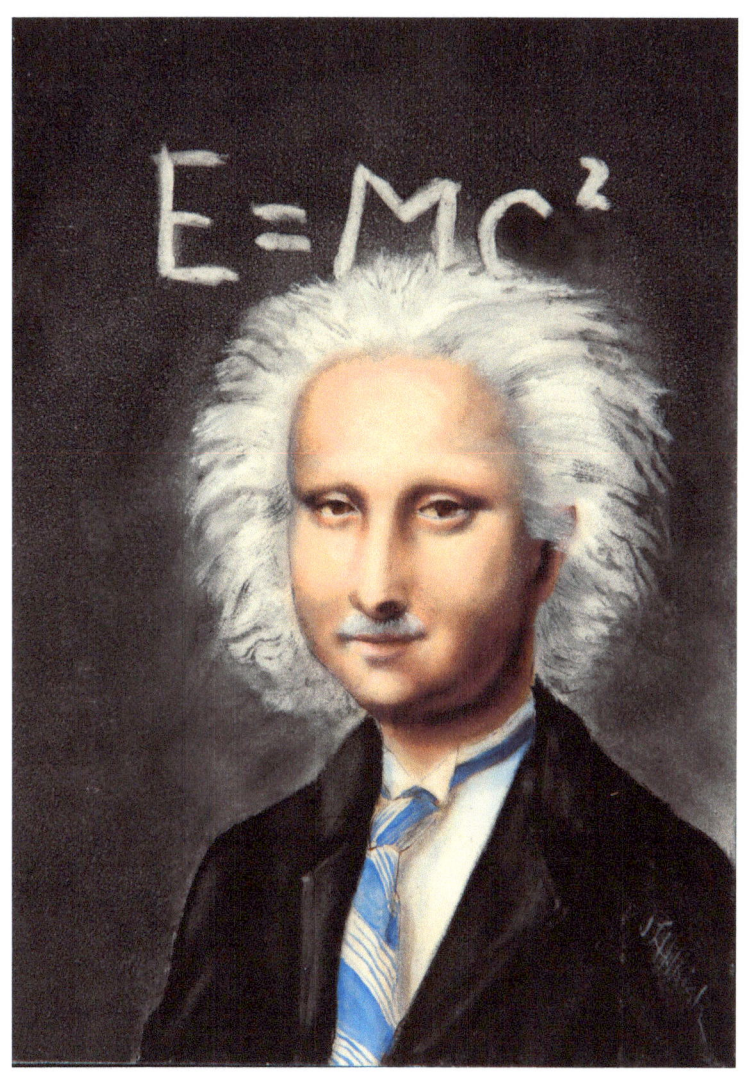

ALBERT EINSTEIN
MEETS MONA LISA

THE PINK PANTHER MEETS MONA LISA

The lack of knowledge never stopped the Pink Panther. With child-like innocence he tackled many projects to the chagrin of those around him. When he decided to become an artist nothing stood in his way. Thus he decided to do a plein air portrait of the Mona Lisa inside the Musée du Louvre. And so the head of the museum's security, Capitaine Yannick Ory called Inspector Clouseau when he saw drips of pink paint trailing through the museum. With his usual stealth, the inspector pursued the Pink Panther only to become lost in the maze of the six floors of the Louvre.

Mona-Opoly

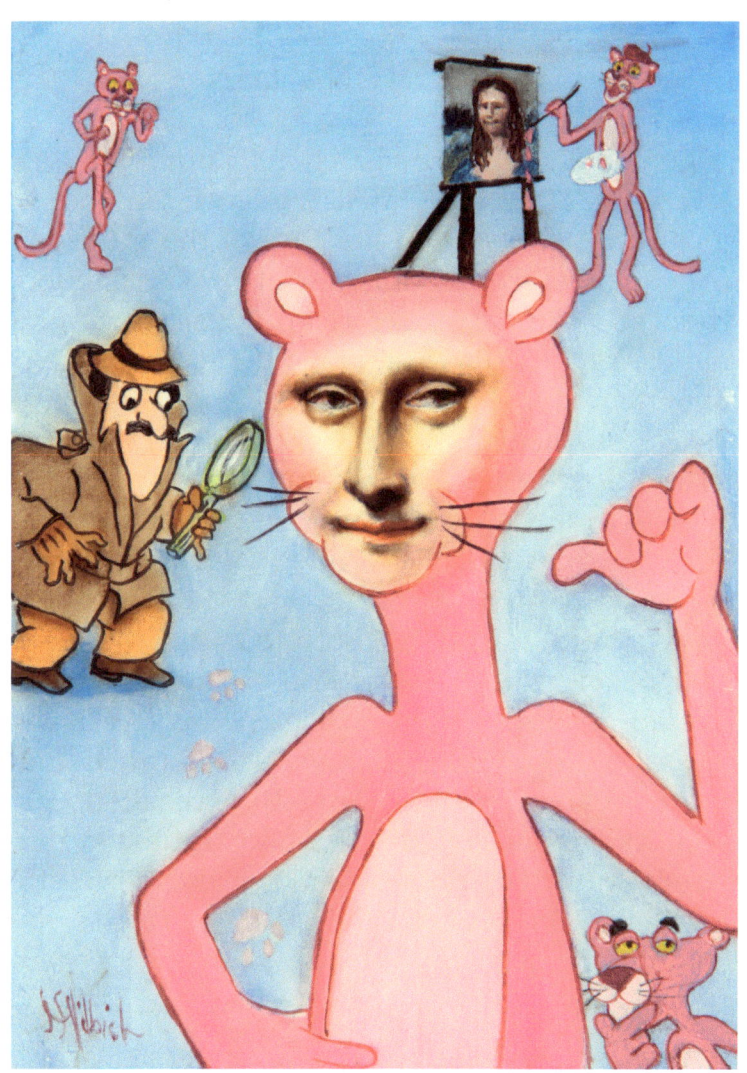

THE PINK PANTHER
MEETS MONA LISA

QUEEN ELIZABETH II MEETS MONA LISA

Queen Elizabeth II visited the Louvre on two occasions, 1957 and 2004. While we may never know what she saw on her tour of the museum we can't help but imagine her satisfaction when she compared her reign with that of her namesake, Elizabeth I, which she may have remembered on viewing Delaroche's painting "Death of Elizabeth" in the Denon wing on the second floor below the Pyramid.

Both queens saw their country through a threatened invasion: Elizabeth I the invasion by the Spanish Armada, and Elizabeth II, World Wars I and II. Both sought to serve their people with honesty and dedication. Both created an atmosphere in which the arts have flourished. Both sought religious tolerance and the unification of the people. But Elizabeth's II reign as well as her life have far outlasted her namesake's. It is no wonder that the Elizabeth II wears Mona Lisa's smile. She surely is an icon of her times.

Mona-Opoly

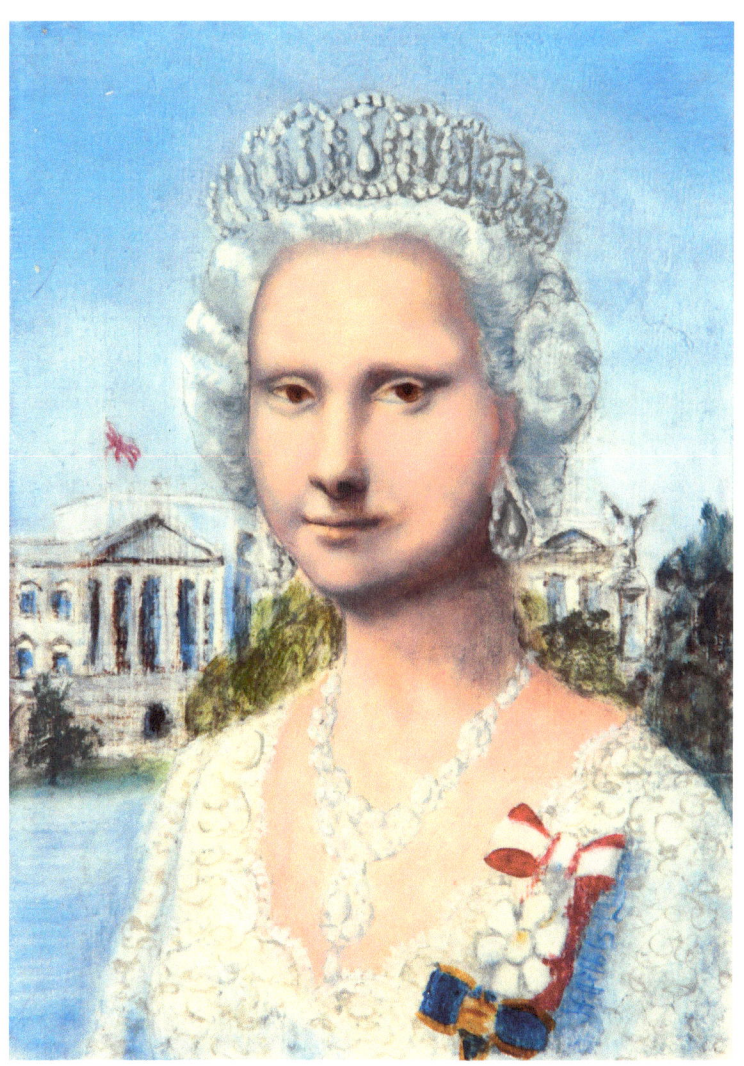

QUEEN ELIZABETH II
MEETS MONA LISA

VINCENT VAN GOGH MEETS MONA LISA

Van Gogh lived a short time in Paris with his brother Theo, an art dealer. During his time there, his paintings were often dark and moody. Perhaps a visit to the Louvre with his brother where he would have seen Mona Lisa prompted his move to Arles, southern France.

At Arles he sought the sun and country lifestyle. Was his statement: "what I really hope to do is paint a good portrait" inspired by that trip to the Louvre? His portraits show an understanding of humanity as only a person who knows the beauty and turmoil of life that is seen with the life and portrait of Mona Lisa.

Mona-Opoly

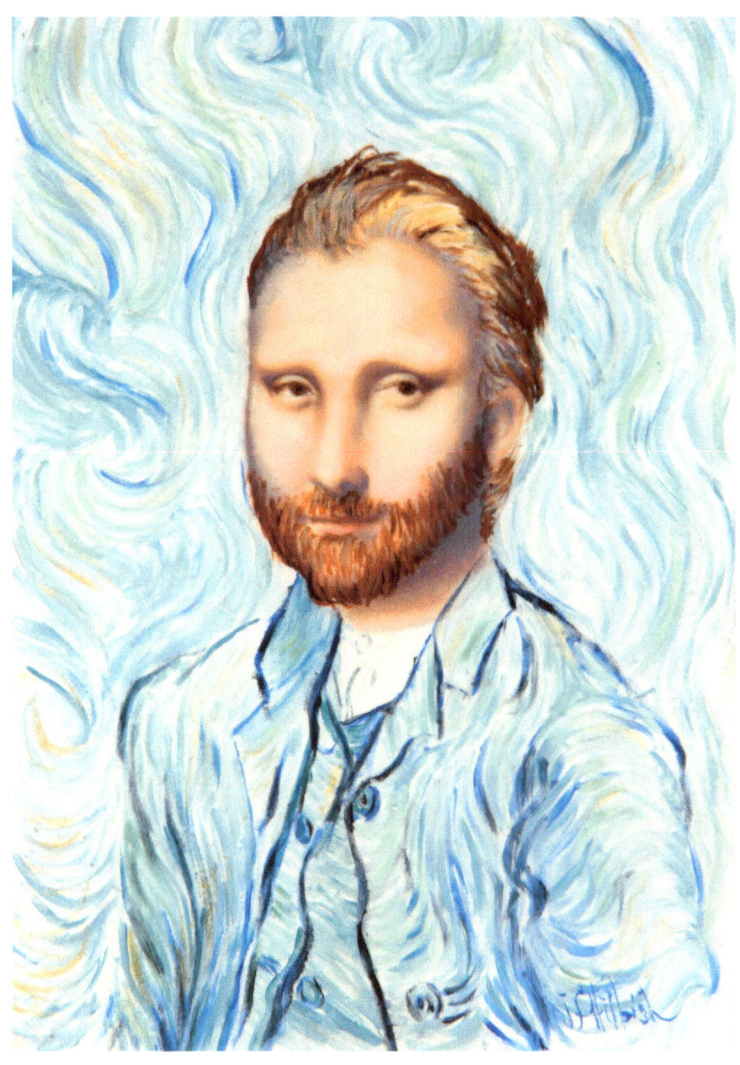

VINCENT VAN GOGH
MEETS MONA LISA

BRÜNNHILDE, THE VALKYRE QUEEN, MEETS MONA LISA

The Italian motorcycle club Valkyrie Riders Italia is not the only one influenced by Norse legends. Long after the Huns and before the Mongols, Vikings and Norseman left their marks across Europe and Eurasia from 800 AD to 1100 AD. They raided Pisa, not far from Florence, the home of Lisa Giocondo, aka Mona Lisa.

Italy had become the melting pot of the Mediterranean incorporating everything that passed through its lands from genetic lines, to religions, to foods, to cultures and arts. The Norse and Vikings left their mark also. The weekdays Wednesday and Thursday were derived from the names of the gods Wotan and Thor. The motorcycle club is just the latest reminder of how Norse mythology has left its mark on Italy.

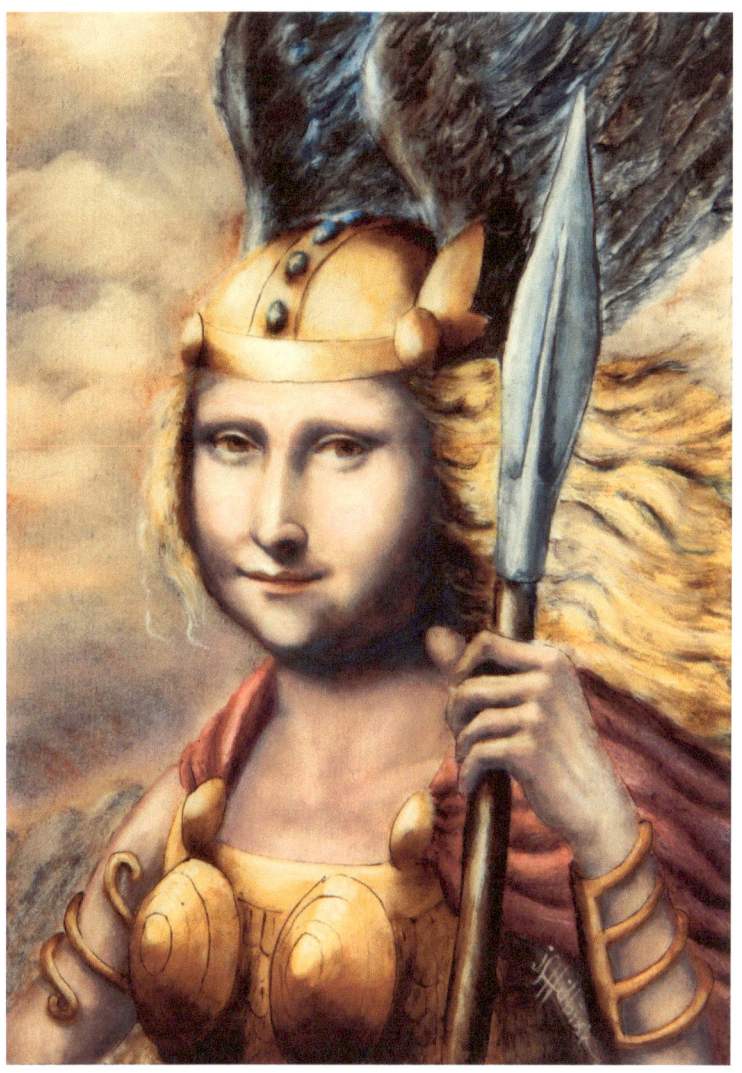

BRÜNNHILDE, THE VALKYRE QUEEN, MEETS MONA LISA

INDIAN JONES MEETS MONA LISA

The following is no-doubt a true story since it comes from the internet: "In September 1908, as part of his education, Indiana Jones went to the museum with his tutor, Miss Seymour. While viewing Leonardo da Vinci's painting, Mona Lisa, Jones made the acquaintance of another American boy, Norman Rockwell, who was sketching the masterpiece. Guided by Miss Seymour, the two friends continued around the museum, where Rockwell was interested in the realism of some of the paintings, such as the nose on Old Man with a Young Boy, and Jones quickly got bored with Impressionist pieces, even ones by Edgar Degas. Sensing that the boys had had their fill of great art, Miss Seymour took them to a puppet show." (http://indianajones.wikia.com/wiki/Louvre)

Thus, the desire to solve the mystery of Mona Lisa was planted in young Indy's subconscious. What did surface was his compulsion to pursue legends and their treasures. He was always thwarted not so much by Belloq as by his subconscious yearning to solve the mystery of Mona Lisa.

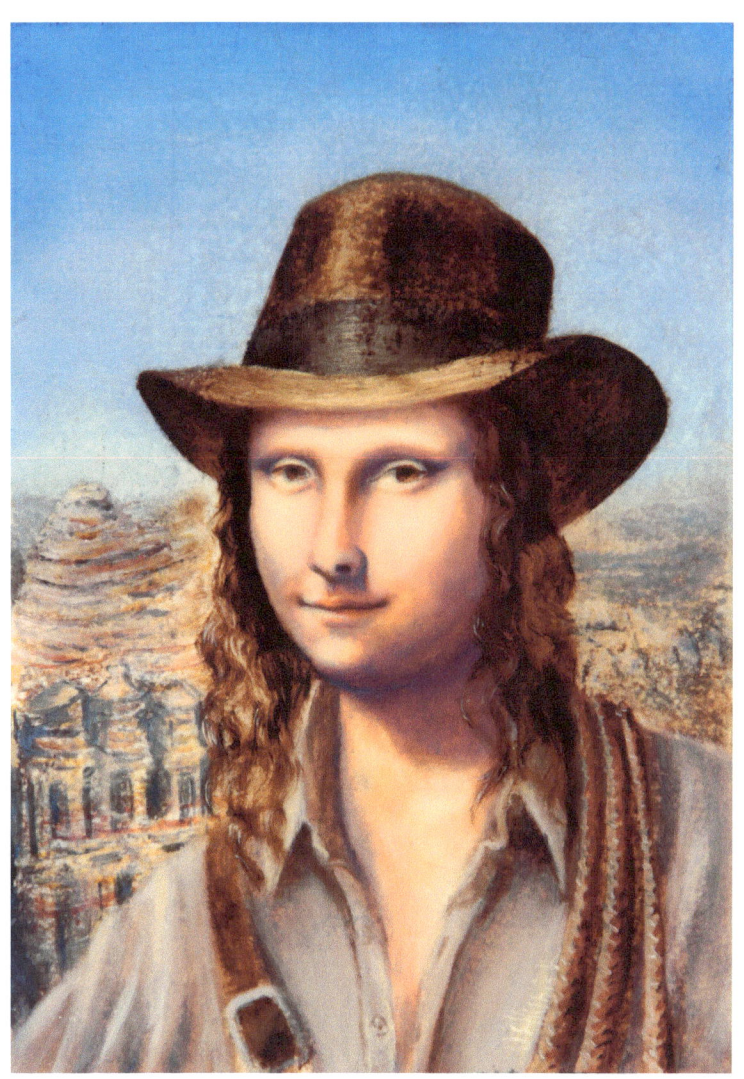

INDIANA JONES MEETS MONA LISA

AMELIA EARHART MEETS MONA LISA

"Pioneering pilot Amelia Earhart would have been a legend anyway, but inscrutability turned her into the aviation equivalent of the Mona Lisa's smile" says Darren D'Addario, (http://afflictor.com/2010/09/06/gleaned-the-search-for-amelia-earhart-1966/).

Did Mr. D'Addario see something in Amelia that others missed?

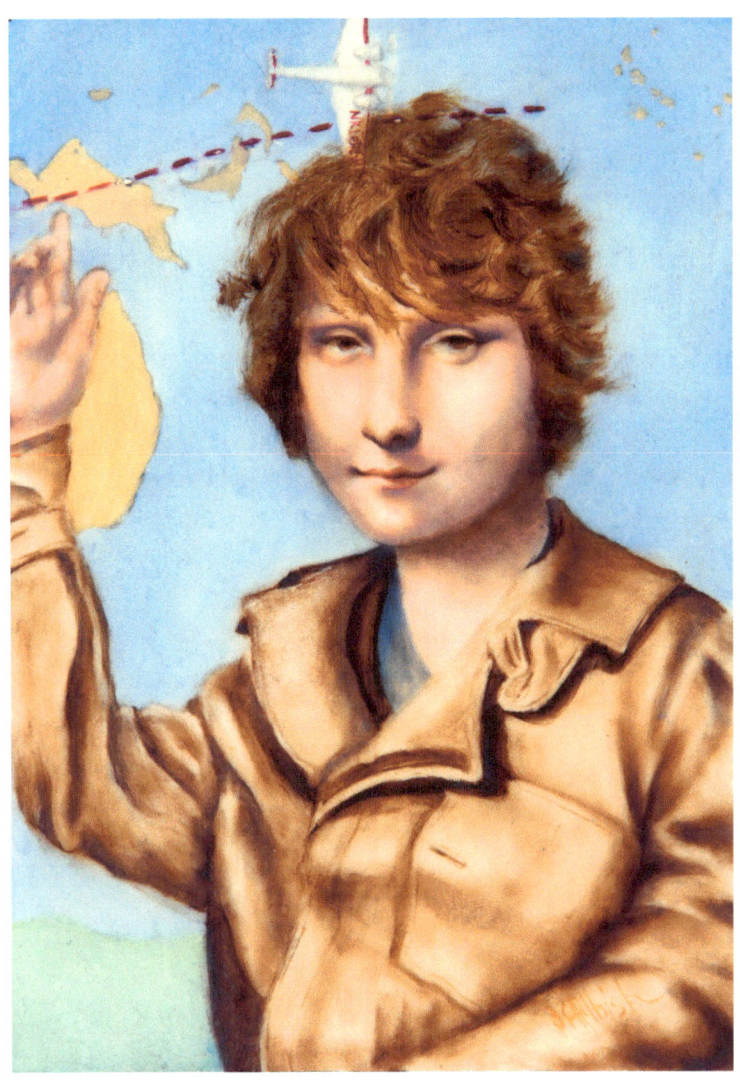

AMELIA EARHART
MEETS MONA LISA

REMBRANDT MEETS MONA LISA

"The entire history of portraiture afterwards depends on the Mona Lisa. If you look at all the other portraits - not only of the Italian Renaissance, but also of the seventeenth to nineteenth centuries. . . all of them were inspired by this painting. Thus, it is sort of the root, almost, of occidental portrait painting," according to Louvre Curator Jean-Pierre Cuzin.

One does not need to look very hard to find elements of Mona Lisa in Rembrandt's self-portait: the sfumato background of muted tones, the graceful hand gesture, the stylish but understated garb. . . .

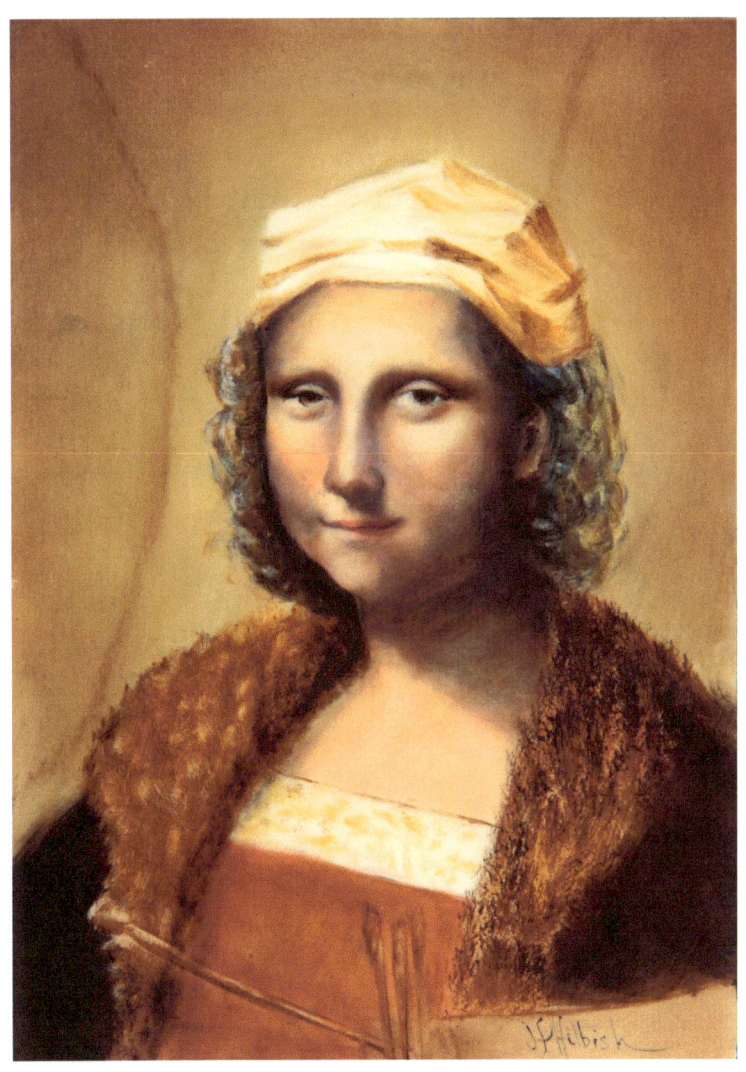

**REMBRANDT
MEETS MONA LISA**

GALILEO MEETS MONA LISA

While more than a hundred years separated the lives of Galileo Galilei and Leonardo da Vinci, these two northern Italian scientists had many things in common. With the human body, Galileo studied medicine before taking up mathematics; Leonardo studied the dissected human body. Galileo loved art; Leonardo created art. Galileo improved the telescope; Leonardo made a lens grinder for telescopes. Galileo studied pendulums, Leonardo invented the catapult. Galileo was a physicist, Leonardo was a mechanical engineer. Both were mathematicians. Galileo showed that the world revolved around the sun, while Leonardo gave artists a new guiding light for the world of portraiture.

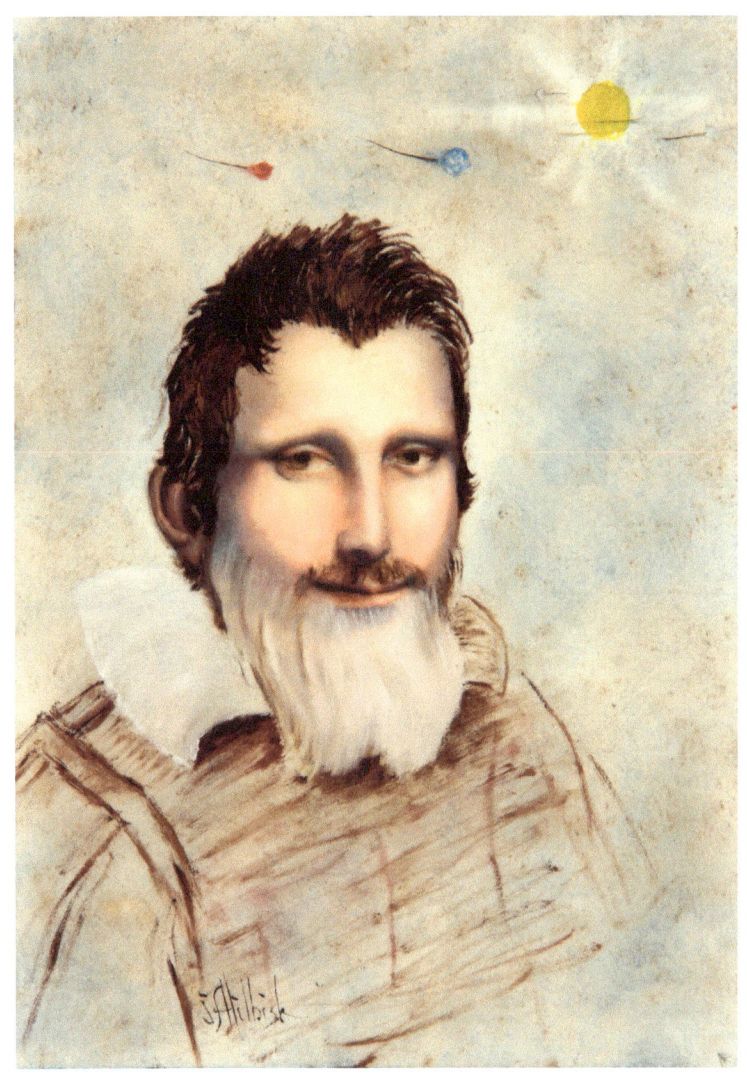

GALILEO MEETS MONA LISA

LUDWIG VON BEETHOVEN MEETS MONA LISA

Ludwig von Beethoven has been well honored in Paris with many statues and streets and even a hotel named after him. Missa Solemnis in D major was composed 1819-1823 by Beethoven for his friend and supporter Archduke Rudolf the Archbishop of Olmütz, at Cologne Cathedral.

Did the cobalt blue color of the stained glass in the cathedral remind Beethoven of the cobalt blue in Leonardo's Mona Lisa, another recipient of Paris' affection? Did Mona Lisa's ethereal veil remind him of the unworldly grandeur of the Cologne Cathedral? Was it actually her serenity and power that inspired the Missa Solemnis in D major?

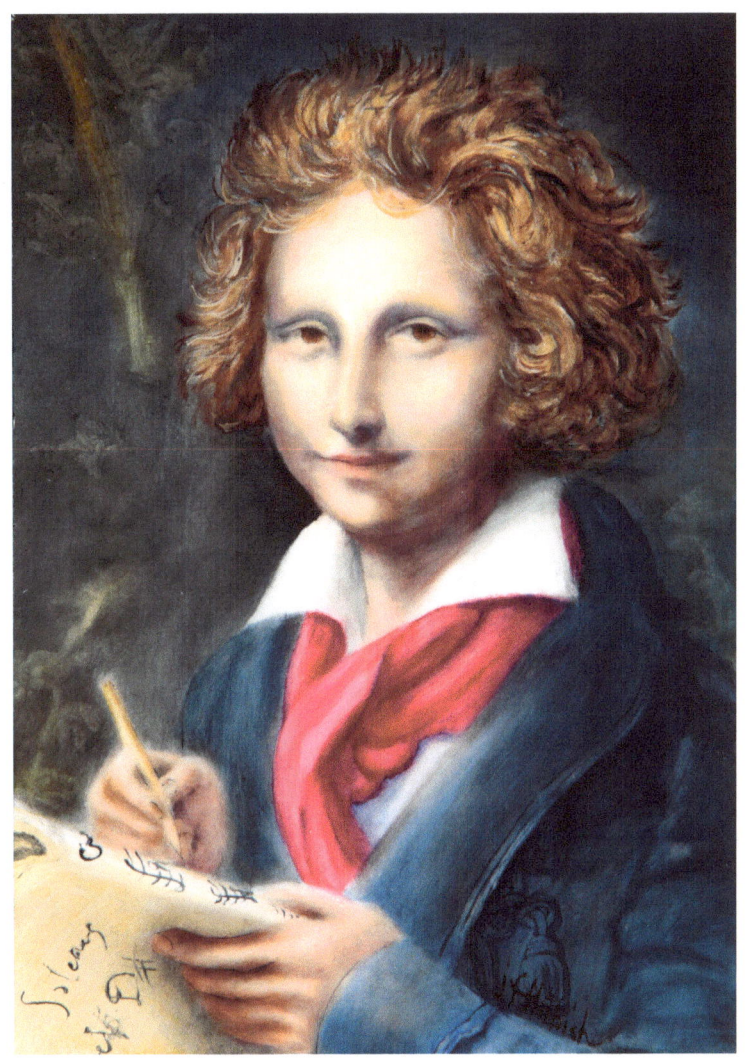

**LUDWIG VON BEETHOVEN
MEETS MONA LISA**

BRIDE OF FRANKENSTEIN MEETS MONA LISA

The Bride of Frankenstein was created after the Monster pleaded with his creator for a mate, someone to love and be loved by. When she was brought to life the Monster reaches out to her and asks "Friend?". She however was repulsed by him. The rejected Monster then destroys the lab, the scientist and his bride. If only they had instilled the heart and smile of Mona Lisa into the bride, things would have had a happy ending.

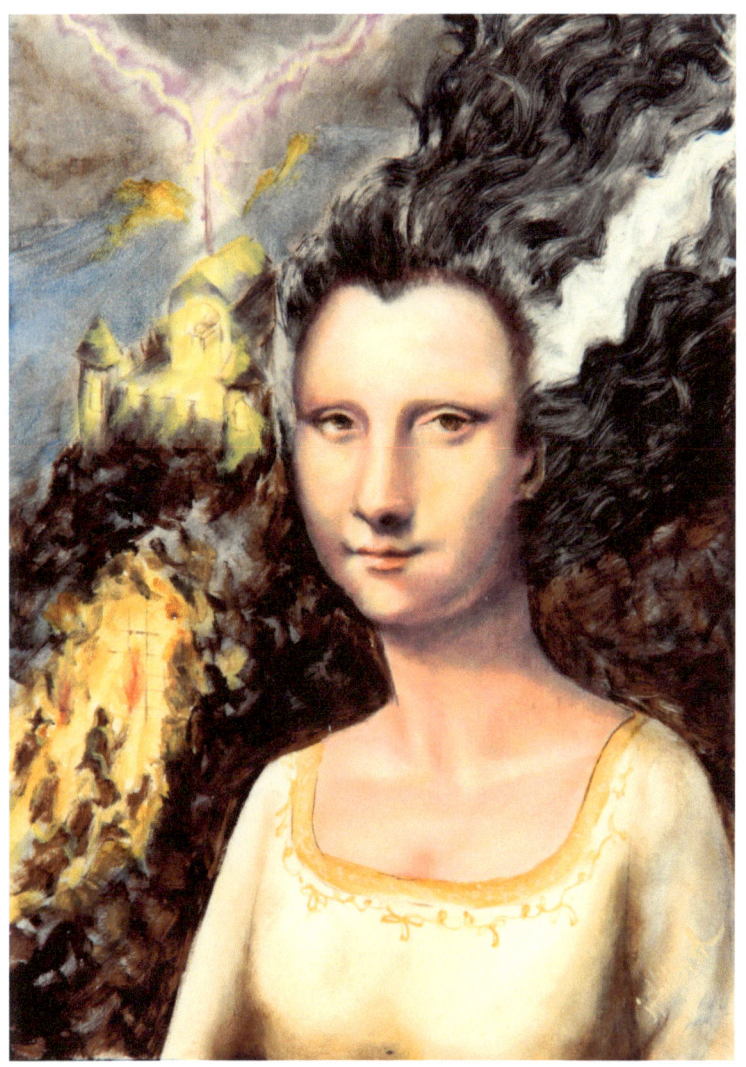

BRIDE OF FRANKENSTEIN
MEETS MONA LISA

GENGHIS KHAN MEETS MONA LISA

Yes, Genghis was born and lived about 200 years before the Mona Lisa was created. In this case though, it may be that Mona was affected by Genghis, rather than the reverse, as seen elsewhere in this series. The Mongol hordes never made it to Italy, but they did make it to Poland. Specifically, Kracow.

Mona Lisa is believed to be the portrait of Lisa del Giocondo, born as Lisa Gherardini in 1479. The Gherardini's traced their lineage back to an ancestor who survived the Trojan war. It was a prosperous and large family and played a significant role in Tuscan history. From these roots, branches of the family moved across Europe as far as Ireland, up to Kracow, Poland, and through France between 1000 and 1400 AD. The branches in France and Poland subsequently died out.

But did the Polish branch feel the effects of the Mongol hordes before being lost to history? Did they survive the onslaught only to retreat back to Tuscany? Does Mona Lisa have Mongol genes? Mona and Genghis are not saying one way or the other. You judge.

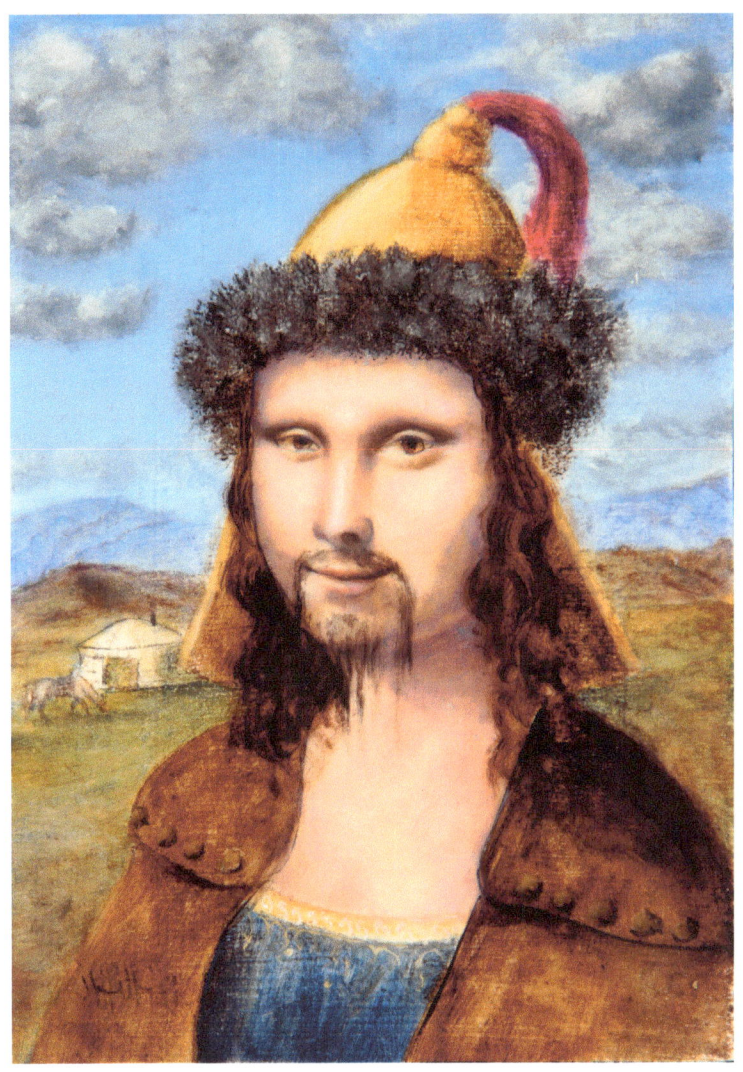

**GENGHIS KHAN
MEETS MONA LISA**

STATUE OF LIBERTY MEETS MONA LISA

Frederic-Auguste Bartholdi was the French sculptor of this American icon. Controversy exists concerning the model for the statue. Some say it was Charlotte Bartholdi, the sculptor's mother. Others say it was Jeanne-Emilie, his mistress who became his wife. There is no doubt that she was based on a Roman goddess. But maybe it was that Italian beauty Mona Lisa?

Mona-Opoly

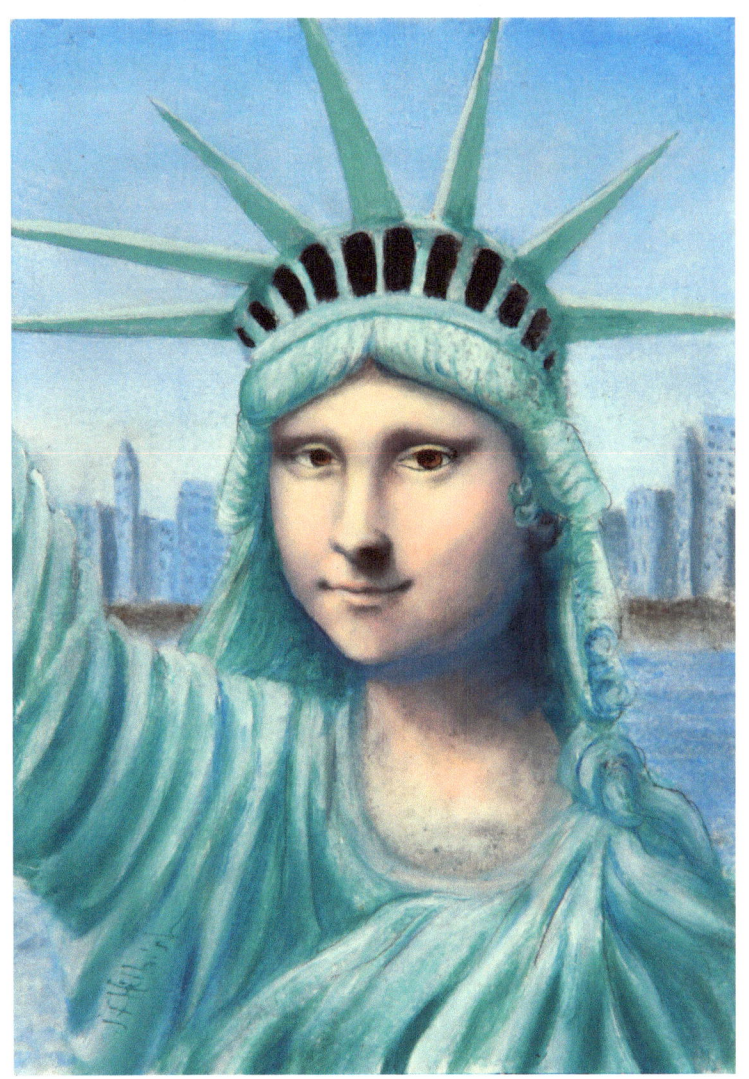

STATUE OF LIBERTY
MEETS MONA LISA

PABLO PICASSO MEET MONA LISA

On August 21, 1911 the Mona Lisa was stolen from the Louvre. The empty space was not notice until the next day. A fiasco the following week with the closure of the museum for the investigation. The usual suspects were rounded up in addition to Guillaume Apollinaire who gave shelter to the thief.

This poet was put in jail as a prime suspect because of his advocation of the burning of the Louvre. While in jail he fingered his friend, Pablo Picasso, as the real thief. Pablo was brought in for questioning but later released along with his jokester friend Guillaume.

It took two years to find the thief Vincenzo Peruggia, a Louvre employee and Italian patriot. Peruggia did succeed in bringing Mona Lisa back to Italy were she toured for a time before being returned to the Louvre. But he was not the only thief. It is clear from this painting that Mona Lisa stole Pablo's heart.

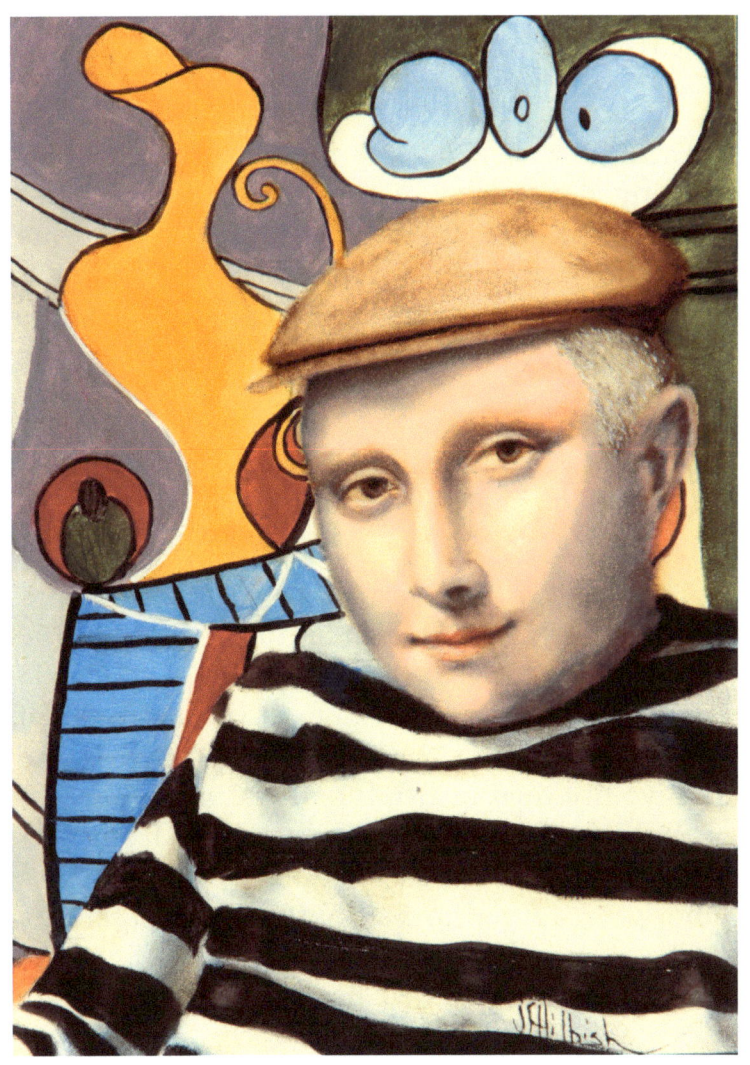

PABLO PICASSO
MEETS MONA LISA

MARLON BRANDO MEETS MONA LISA

Brando was a legend in his own time. He challenged himself with different character rolls and different acting situations. He was drawn to the drama of the human condition and sought those roles. The one movie he directed, "One-Eyed Jacks," was to be an epic of human betrayal. His cut version was over four hours long. He obviously enjoyed this undertaking as he had a big smile on the set in behind the scenes shots taken of him in front of a picture of Mona Lisa.

The tragedy of the film was not as the script depicted but what the studio did to it. Not only were hours cut from the film, the studio also changed the ending, leading to a betrayal of Brando's vision for the film. Many say that the creative fire died in Brando after that.

Perhaps if he had drawn strength from that picture of Mona Lisa hanging on the set of "One-Eyed Jacks" and adopted her mysterious smile, he could have found strength to fight the studios for the kind of films he wanted while he continued to beguile Hollywood fans.

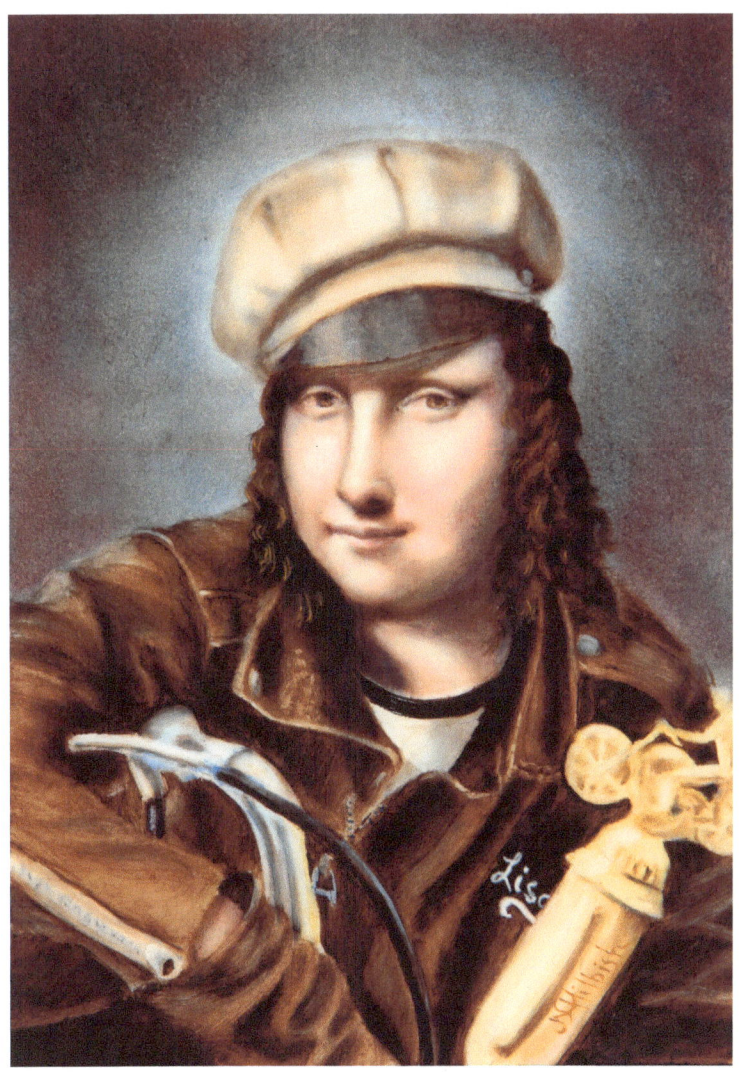

MARLON BRANDO
MEETS MONA LISA

RICH UNCLE PENNYWORTH, AKA MR. MONOPOLY, MEETS MONA LISA

Rich Uncle Pennyworth changed the nature of board games, making Monopoly the most successful board game in history. It has had many spin-offs, but is still the most successful game ever and Rich Uncle Pennyworth has become known as Mr. Monopoly.

Likewise the portrait of Lisa Giocondo changed the nature of portrait art and became the standard for all others. Many others have copied Leonardo's style, but none have matched it. Known now as the Mona Lisa, she has become the most admired portrait in the world.

Success is hard to beat unless it is combined with another success as seen here.

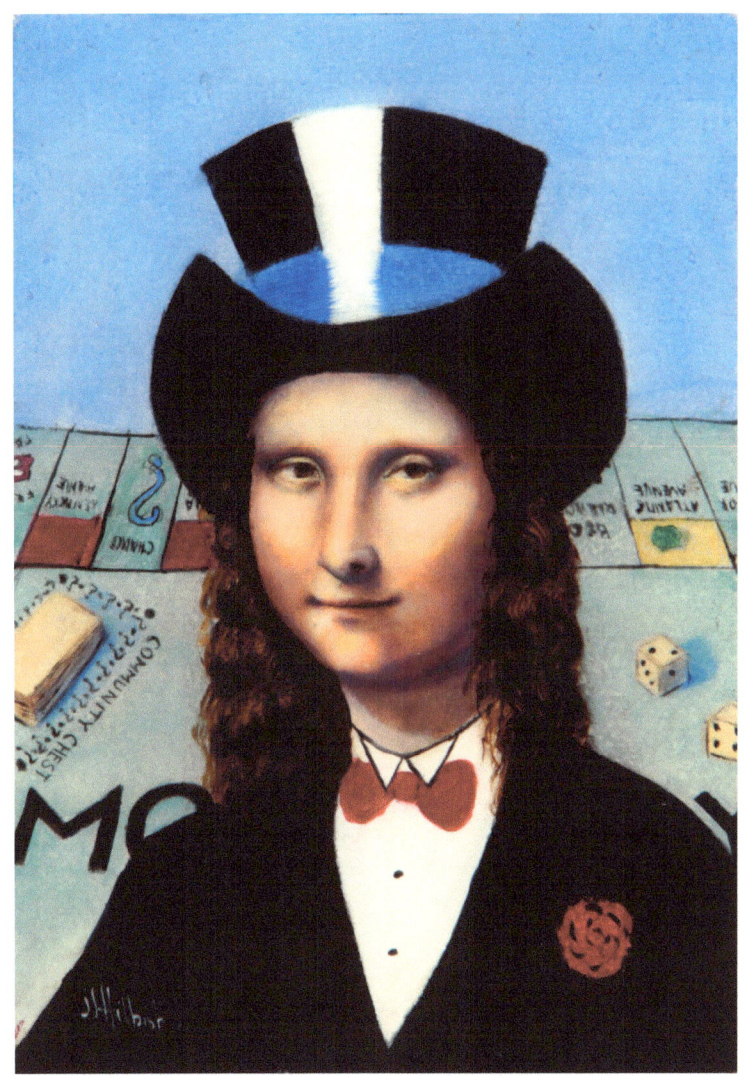

MR. MONOPOLY
MEETS MONA LISA

Hilbish

Mona-Opoly

Artist/Author Prattle

Judy Hilbish is affected by Mona Lisa just as many people have been, often in ways we may never know. It was surprising to the artist when she put down her brushes and started researching the lives of the famous people portrayed in the series, *Mona-Opoly*, how often there were connections between them and Mona Lisa. The majority of the stories found here are based on facts although the conclusions are as fanciful as the paintings.

The oldest method of learning is to study and copy a master so Judy turned to Leonardo da Vinci to study his technique of portaiture and developed a fascination with Mona Lisa. But she was then faced with a problem; how many Mona Lisas could one paint and still be considered sane? So the idea for *Mona-Opoly* was born.

Mona-Opoly is painted with a technique adapted from Leonardo: a grisaille background of umber followed by individual glazes of cobalt blue, vermillion, and transparent yellow iron oxide, followed by highlights with lead white for Lisa and many of the backgrounds. For some of the backgrounds more contemporary pigments were used. All of the paintings are originals on 7 by 5 inch panels and are available for purchase at JudyHilbish.com. Look for another creation of fanciful realities, *Crazy Capers of the Culinary World*, to be released soon.

www.ingramcontent.com/pod-product-compliance
Lightning Source LLC
Chambersburg PA
CBHW040923180526
45159CB00002BA/581